Button Centers

Add dimension and a touch of whimsy to flower centers with brightly colored buttons.

1. Draw the outline of the flower, center, leaf, and stem with a pencil. Use a circle template if desired.
2. Draw tangles in each section with a black MICRON 01 pen. Fill in some tangles.
3. Add colors to the sections with watercolor markers, or with watercolor paints and a small paintbrush.

Techniques and Tools

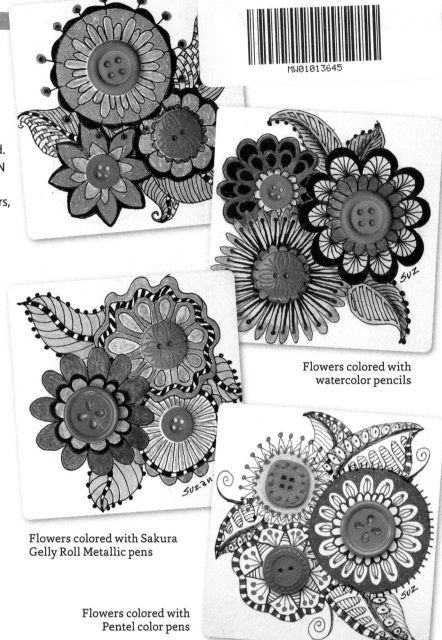

Flowers colored with watercolor pencils

Flowers colored with Sakura Gelly Roll Metallic pens

Flowers colored with Pentel color pens

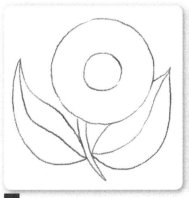

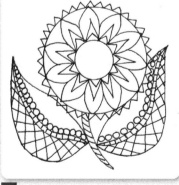

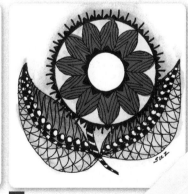

Basic Steps for Adding Color

1. Draw the outline of the design with a pencil.
2. Draw tangles with a black MICRON 01 pigment ink pen by Sakura.
3. Fill in the sections with watercolors using a paintbrush and water.

How to Get Started with Traditional Zentangle

A very simple ritual is part of every classic Zentangle, and you can follow the ideas in this book the same way. A true classic Zentangle is created on a custom Zentangle die-cut tile of archival print-making paper. Use a black Pigma MICRON 01 pen by Sakura to draw the tangles and to sign your Zentangle.

1. Make a dot near each corner of your paper tile with a pencil.
2. Connect the dots to form a frame.
3. Draw guidelines, called strings, with the pencil. The shape can be a zigzag, swirl, X, circle, or just about anything that divides the area into sections. The strings will not be erased but will disappear, becoming part of the design.
4. Use a black pen to draw patterns, called tangles, in each section formed by the strings. When you cross a line, change the pattern. It is OK to leave some sections blank.

TIP: Rotate the paper tile as you fill each section with a tangle.

What you'll need to get started

- a pencil
- a black permanent marker—a Pigma MICRON 01 pigment ink pen by Sakura is suggested
- smooth white art paper—a Zentangle die-cut paper tile is suggested (3½" x 3½" [9 x 9cm])

Use a pencil to make a dot in each corner.

Connect the dots with the pencil.

Draw a string with the pencil as a guideline. Try a Z zigzag, a loop, an X, or a swirl.

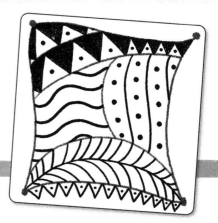

Switch to a pen and draw tangles in each section formed by the string. When you cross a line, change the pattern. It is OK to leave some sections blank.

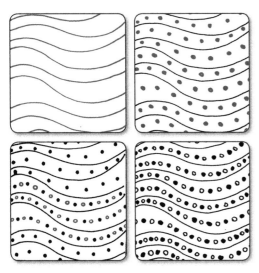

Wavou

1. Draw curved lines to fill the square.
2. Draw dots between the lines, leaving space between the dots for circles.
3. Draw circles between the dots.

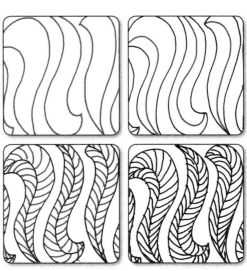

Blades

1. Draw pairs of swirly shapes.
2. Draw a center line down each shape.
3. Draw short lines to connect each center line to the outside lines.

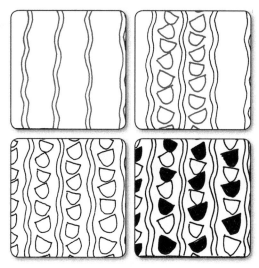

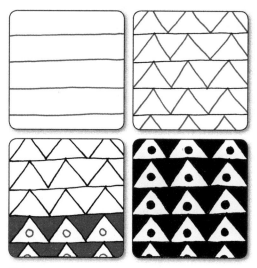

Teac

1. Draw pairs of wavy lines.
2. Draw cup shapes between the lines.
3. Fill in every other cup in each column with black.

Try

1. Draw horizontal lines.
2. Draw a zigzag between each line to form triangles.
3. Draw a small circle in every other triangle.
4. Fill in the circles and background triangles with black.

ZIAs

Traditional Zentangle designs are nonobjective and have no recognizable shape or orientation. The string divides the sections. ZIA is an abbreviation for Zentangle-Inspired Art. Anything tangled with color, not on a square tile, or with a specific orientation is considered a ZIA.

Shading with Color

Shading adds a touch of dimension. Use the side of a color pencil to gently color areas and details. Dampen a small brush with water. Use the brush to go over the color pencil area so the color blends and adds a soft shaded edge.

Use shading sparingly. Be sure to leave some sections white.

Each tangle is a unique artistic design, and there are hundreds of variations.

Helpful Tips to Remember
- Hold your pen lightly.
- Remember to breathe.
- Be deliberate when making a stroke.
- Take your time drawing tangles.
- Draw your strokes fluidly.
- Turn your tile from time to time.
- Stand back from your tile to view your work.
- There are no mistakes, only opportunities.
- It is okay to leave your work and come back later.
- Enjoy the process.

A tangle a day keeps stress away!

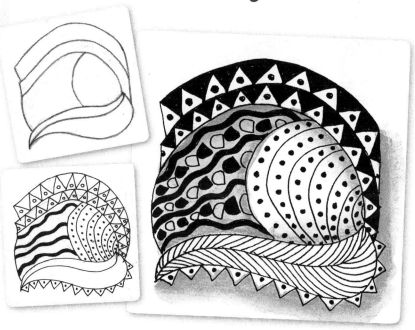

Add Shading with a Watercolor Pencil

1. Color areas with the watercolor pencil.
2. Using a damp paintbrush (or a water brush), gently stroke over the colored area to blend the colors.
3. Let the color dry.
4. Shade areas as desired.

Daylight Tile

1. Use a black MICRON 01 pen to draw a Daylight design (see page 5) in each corner of a paper tile.
2. Fill in areas with black, blue, and sepia MICRON 05 pens.
3. Add shading to the design with a graphite pencil.

1

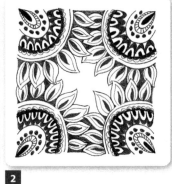

2

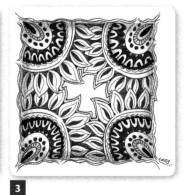

3

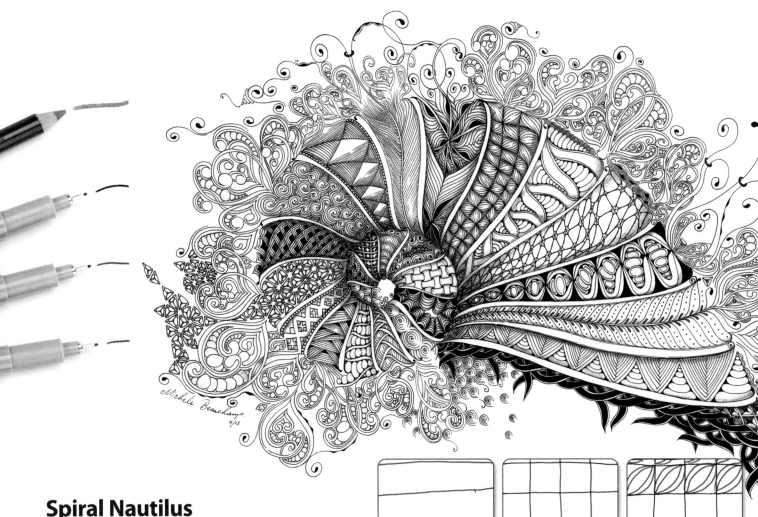

Spiral Nautilus

by Michele Beauchamp, CZT (Tasmania)
www.shellybeauch.blogspot.com

Michele's specialty is spiral shapes. She created this beautiful nautilus design with only three colored MICRON pens (black, sepia, and blue) and shaded it with a hunter green Prismacolor pencil.

Sliva

Variation

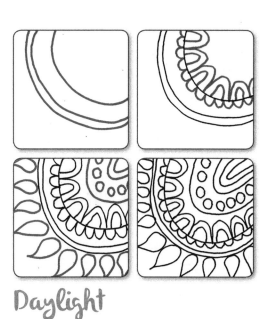

Daylight

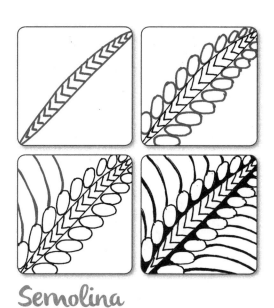

Semolina

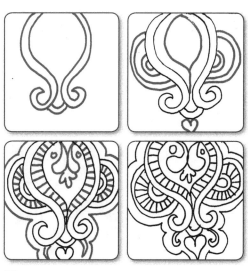

Taj

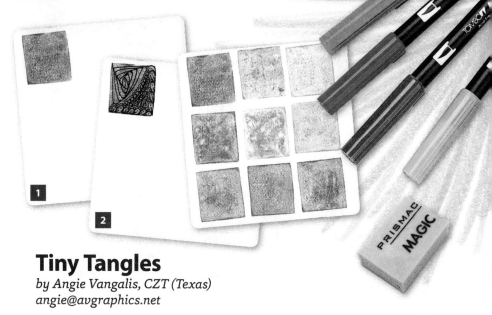

Tiny Tangles

by Angie Vangalis, CZT (Texas)
angie@avgraphics.net

Did you know that you can use an eraser as a stamp? Angie cut a 1" (2.5cm) square block stamp from a white vinyl eraser. You can make your stamp any size and shape you want.

1. Carefully cut an eraser into a 1" (2.5cm) square. Add color to the square shape with a brush marker (Tombow, Koi,v or Marvy are good markers) or a stamp pad. Transfer the color from the square by pressing or stamping the colored side to a tile or paper surface. Apply more color to the square and stamp as many squares as desired.
 Tip: Clean off leftover color with a baby wipe.
2. Draw tangles inside each stamped square with a black MICRON 01 pen.

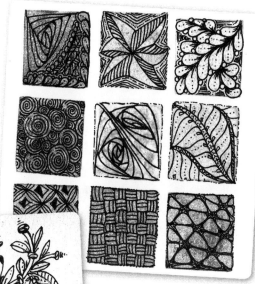

Patchwork Tiny Tangles: Stamp nine squares in a grid.

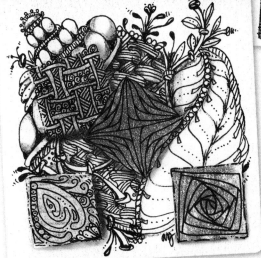

Embellished Tiny Tangles: Draw a tangle design to connect the square shapes.

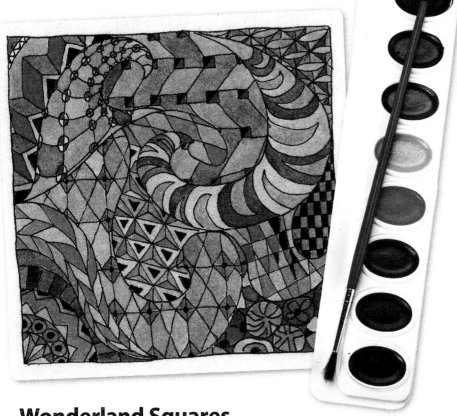

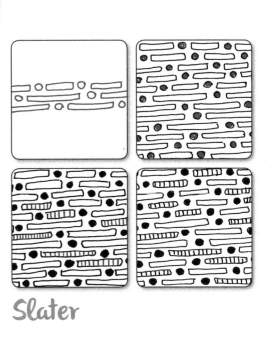

Wonderland Squares

by Susan Wing (New Mexico)
foodarts56@msn.com

Shapes swirl in and out on this design, creating depth that pulls your attention into the piece as your eye travels across Susan's intriguing patterns and colors. Susan loves drawing and coloring tangles.

Slater

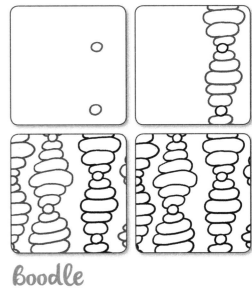

Boodle

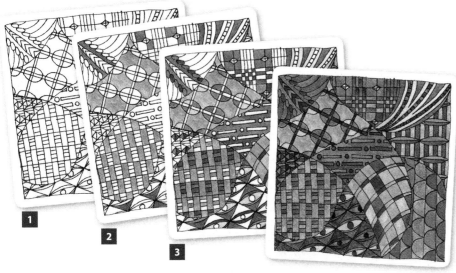

1. Draw tangles with a black MICRON 005 pen.
2. Paint the first color. Use watercolor paints and sizes 0, 1, and 2 small brushes to mix tints and shades. Let dry.
3. Apply the next colors. Let dry.
4. Apply more paint to layer the other colors.

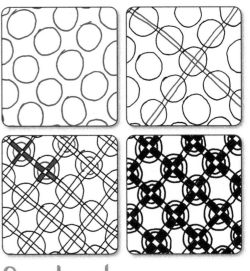

Quartered

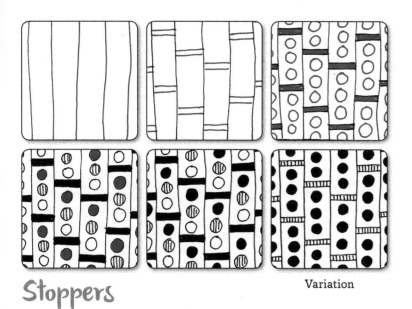

Stoppers

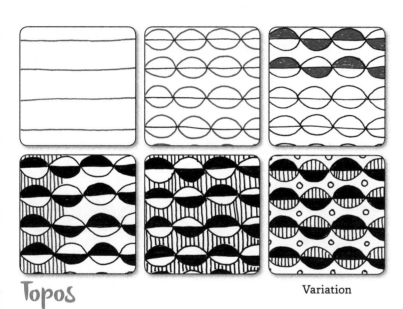

Topos

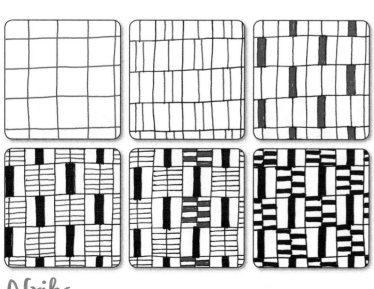

Afrika

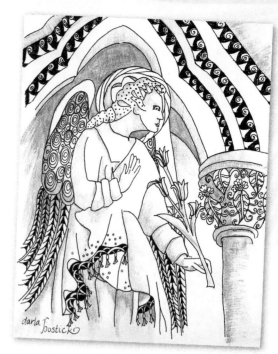

Angel of Salisbury

by Darla Bostick (Texas)
www.darlabostick.com

Heavenly art is inspired by awesome architecture! Experience great art at your local museum, historic building, and online. Darla's travels ignite her creative energy and spill into her art.

1. Draw the angel shape with a pencil on 140# CP watercolor paper.
2. Draw the outline of the design with a black MICRON 01 pen. Draw tangles in the sections.
3. Fill in tangles with a black MICRON 08 pen.
4. Shade the design with Faber-Castell Goldfaber Aquarelle pencils. Darla used a gold color pencil. Paint over the gold color with water and a brush to blend the colors and add shading to the design.

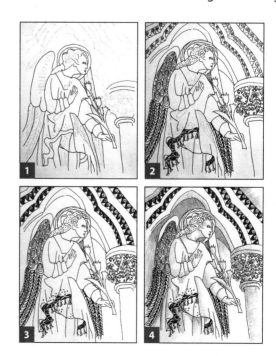

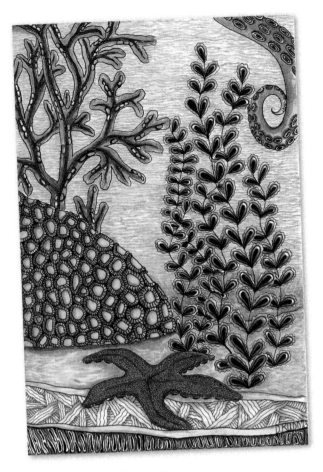

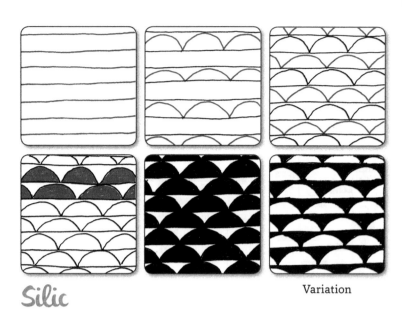

Silic Variation

Octopus Garden

Denise Rudd, CZT (New Mexico)
ariesgrl16@msn.com

Kelp fronds wave gently in a seabed of coral. Capture the peace and mystery of the sea and its fascinating textures with tangles. Denise colored her design with Copic markers. Use the lightest colors first, add the medium shades, then add the darkest colors last.

More Variations of Silic

 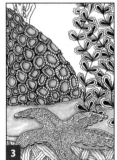 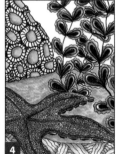

1. Draw tangles with a black Copic Multiliner SP pen, sizes .005, .1, and .35. Then start coloring with Copic markers as listed in steps 2–6.
2. Fill in the honeycomb coral.
 G24 Willow, YG03 Yellow Green, YG05 Salad, N2 Neutral Grey 2, E31 Brick Beige, C5 Cool Grey 5
3. Fill in the sand.
 E13 Light Suntan, E15 Dark Suntan, E31 Brick Beige, E51 Milky White, E55 Light Caramel

4. Fill in the starfish and seaweed.
 Starfish: YR02 Light Orange, E13 Light Sunburn, E15 Dark Sunburn; Seaweed: G24 Willow, G99 Olive
5. Fill in the octopus.
 N2 Neutral Grey 2, C5 Cool Grey 5, W4 Warm Grey 4
6. Fill in the water.
 BG10 Cool Shadow, B00 Frost Blue, BG72 Ice Ocean, BG70 Ocean Mist, Colorless Blender

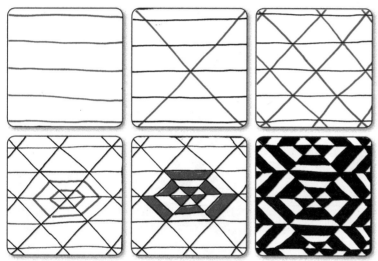

Poin

Whoa

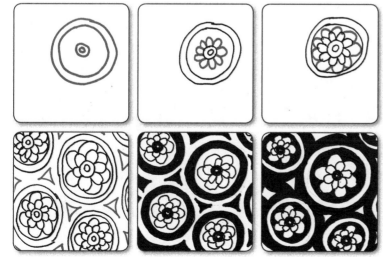

Centro

Variation

Colorful Bird Tags

Birds add color, cheer, and character to tags and tiles. Use colorful tags for accents and gifts. A mylar stencil was the perfect choice for practicing with Pan Pastel colors for the background and for the subjects. The stencil used here was a 3-Way series of 6 birds by Free Range Rubber.

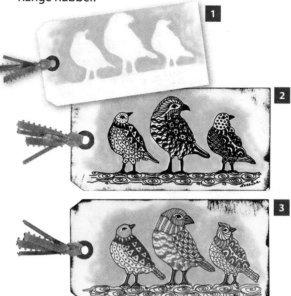

Background

1. Using a plastic stencil, apply Pan Pastel colors to the background with a foam applicator.
2. Draw tangles with a black MICRON 01 pen.
3. Draw tangles with color MICRON 01 pens.

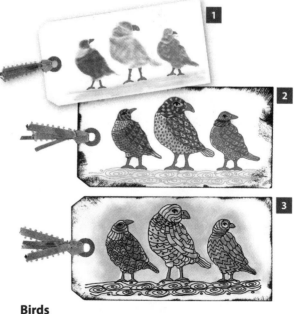

Birds

1. Using a plastic stencil, apply Pan Pastel colors to the birds with a foam applicator.
2. Draw tangles with a color MICRON 01 pen.
3. Draw tangles with black MICRON 01 pens.
Optional: Apply Pan Pastel color to the background.

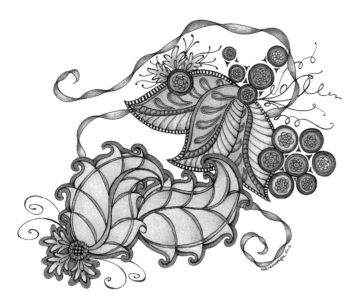

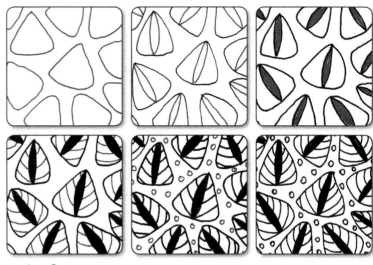

Petalo

Tranquility in Nature

by Kate Lamontagne, CZT (Massachusetts)
www.kamalaboutique.com

Kate's favorite method to color tangles is to use many layers of Prismacolor pencils; it really makes them glow. She chose a beautiful collection of soothing, cool colors that reflect tranquility.

1. Draw tangles with a black MICRON 01 pen. Pick three colors to blend. Very lightly lay down the lightest color.
2. Then lightly lay down the next color so the first color shows through.
3. Layer on the final color, allowing all of the layers to shine through and blend.

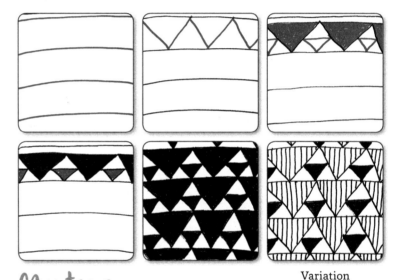

Montana Variation

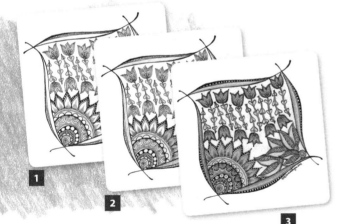

Poke Leaf and Perfs

by Marizaan van Beek, CZT (South Africa)
marizaanvb@gmail.com

This beautiful design used a curved string with tangles in between. Marizaan drew the design with a black MICRON 01 pen, then shaded with 2B, 3B, and 5B graphite pencils. She added Derwent Inktense watercolor pencils to create the glowing color, then used a brush to add a small amount of water to blend the pigment of the inks.

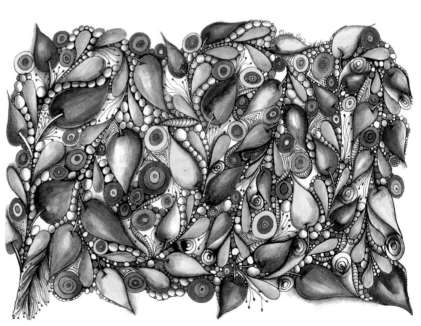

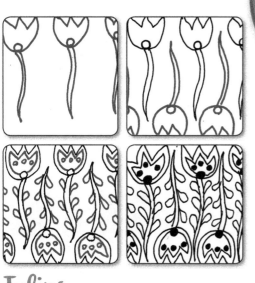

Tulips

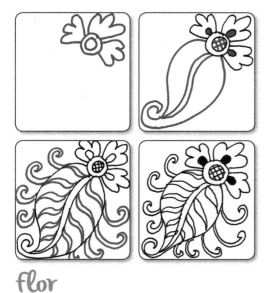

Flor

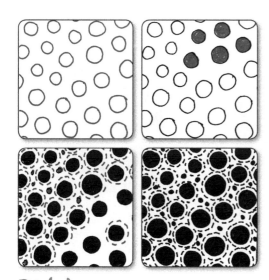

Didot

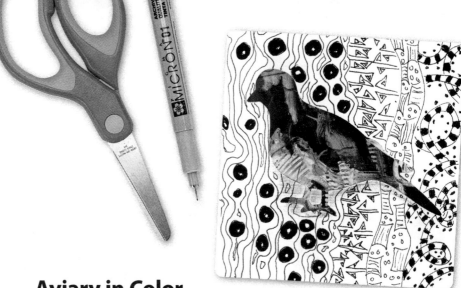

Aviary in Color

by Lee Kellogg (New Mexico), www.stampafe.com

This technique offers an opportunity to use a tangled tile as a background for a new piece of art. This is a simple technique, great for beginners. Start by cutting out a shape or using a die cut shape (Lee used a Tim Holtz bird).

1. Cut out or die cut a bird shape from a colorful page torn from a magazine.

2. Trace around the shape with a pencil, then start drawing tangles in the background with a black MICRON 01 pen.

3. Fill the rest of the background with tangles. You can tangle over the lines into the bird shape. When you're done tangling, adhere the bird to the background.

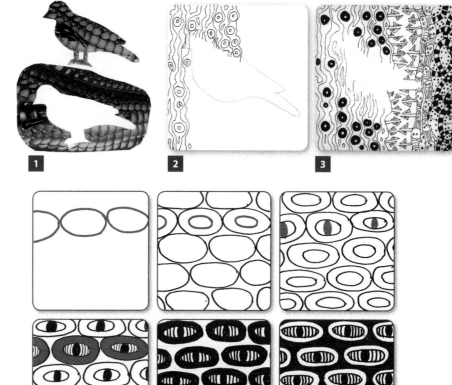

Pupil

Variation

Four Seasons

by Janice K. Freiheit, CZT (Texas)
JaniceFreiheit@gmail.com

Janice created these sumptuous tags steeped in color by combining layered inks with rubber stamp images. She added tangles to each tag to complete the wonderful designs. Janice says she is "not really an artist, but this method makes me feel like one."

Tips for using Distress Inks:

- Saturate the colors heavily when applying.
- Rub ink into the tag in a circular motion.
- Blend each color into adjoining colors.
- Ranger/Tim Holtz Distress Inks are recommended (Mustard Seed, Crushed Olive, Barn Door, and Tea Dye were used on these tags).

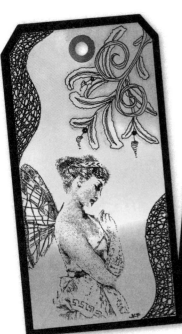
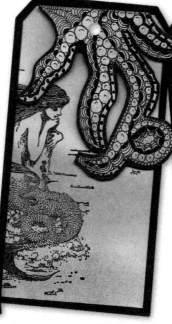
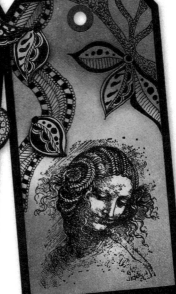
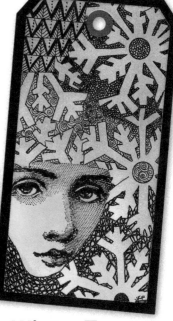

Spring Tag

Distress Inks: *Mustard Seed, Spun Sugar, Peacock Feathers*
Image: *Lost Coast Designs—"Winged Girl"*

Summer Tag

Distress Inks: *Mustard Seed, Crushed Olive, Wild Honey, Peacock Feathers*
Image: *LaBlanche—"Musing Murmaid" (LB1292)*

Fall Tag

Distress Inks: *Mustard Seed, Crushed Olive, Barn Door, Tea Dye*
Image: *Lost Coast Designs—"Cosmos Face"*

Winter Tag

Distress Inks: *Mustard Seed, Spun Sugar, Broken China*
Image: *Stampland—"Woman's Face"*

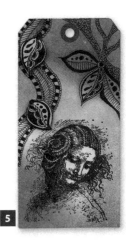

1. Stamp Mustard Seed onto the middle of a tag. It is always best to start with the lightest color.
2. Add Crushed Olive and Tea Dye to the upper and lower corners.
3. Add Barn Door to the remaining areas. Lightly brush Tea Dye over the red areas to tone them down.
4. Stamp an image onto the tag with Black.
5. Draw tangles as desired. Shade as desired.

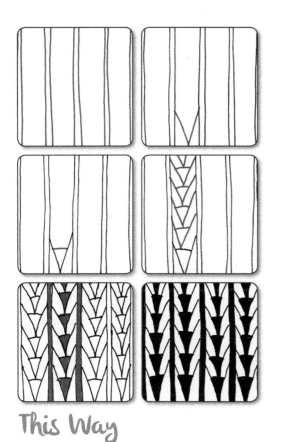

This Way

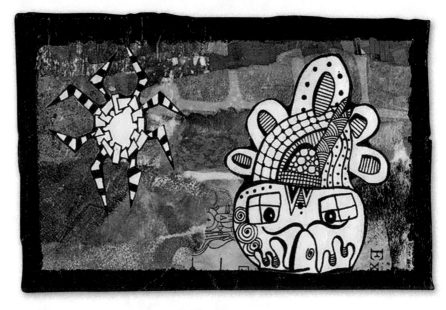

This Old Tangled House

by Cindy Shepard, CZT (Texas)
cyndali.blogspot.com

Cindy's recycled collage art embraces the unexpected with inspiring forms, whimsical shapes, and expressive compositions. She combined her tangled house and sun with a simple collage background.

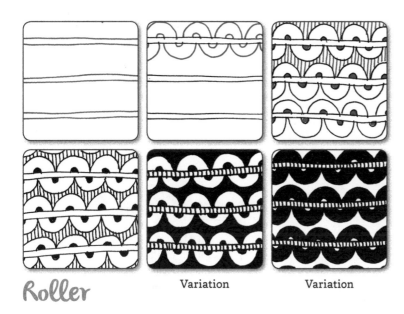

Roller Variation Variation

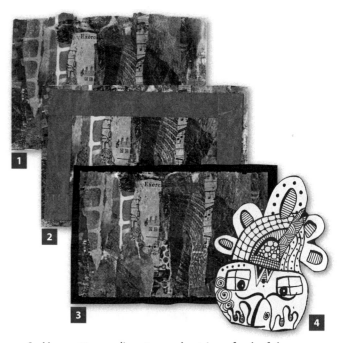

1. Use matte medium to apply strips of colorful magazine pages and color papers to cardstock.
2. Create a frame with blue painter's tape.
3. Apply black paint to the border. Remove the tape. Finish with a coat of matte medium.
4. Draw tangle designs (a house and sun) on white cardstock with a black MICRON 03 pen. Cut out the designs (either use an original or a photocopy). Adhere the designs with matte medium.

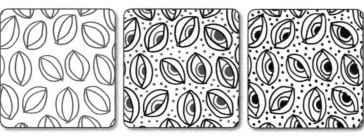

Eyees

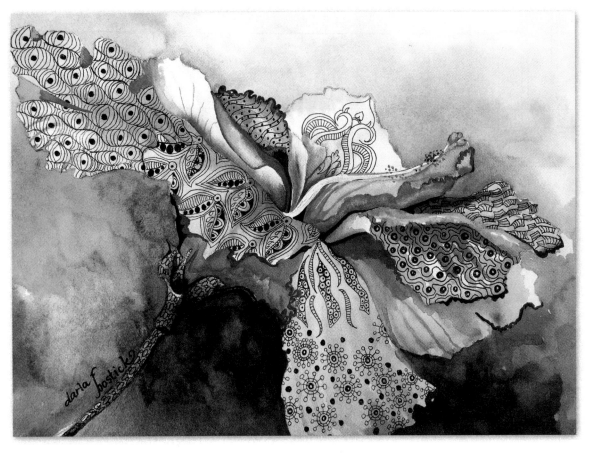

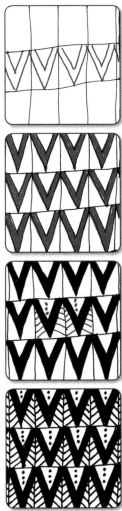

Victory

Tangled Hibiscus

by Darla Bostick (Texas)
www.darlabostick.com

Found objects are often inspiring. Darla found this gorgeous hibiscus flower on a beach and had to start painting and tangling right away. Watercolor paints, 140# CP watercolor paper, and paint brushes were used to capture the image of this hibiscus flower.

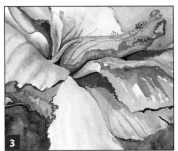

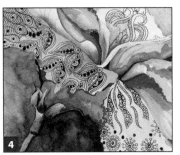

1. Gather the supplies and tools. Use a pencil to lightly sketch the flower design on watercolor paper.
2. Paint the background. Apply water to the background, leaving an open space for the flower petals. Quickly drop wet colors of paint into the pool of water. The paint will blend to create a beautiful background of colors. Allow to dry.

3. Paint the flower. Apply water to the flower petals. Quickly drop wet colors of paint into the pool of water. The paint will blend to create a colorful flower. Allow to dry. Add additional color to darken and alter the petal colors as desired. Allow to dry.
4. Draw tangles on the flower petal sections with a black MICRON 03 pen.

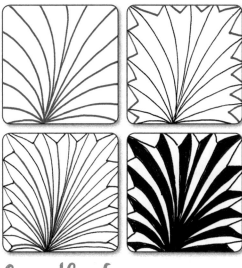

Broadleaf

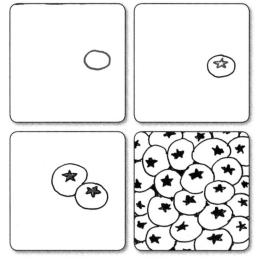

Maters

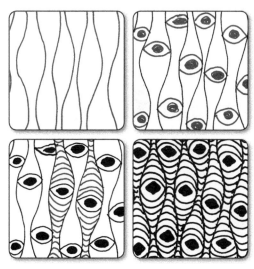

Tree Rings

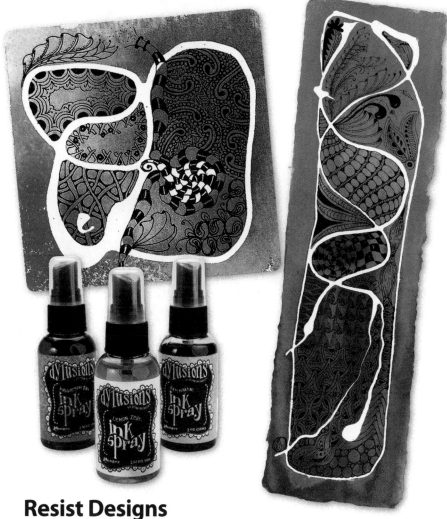

Resist Designs
by Dennie York, CZT (New Mexico), www.dentangles.com

Tangles really stand out when nestled against a harmonious blend of color and framed by a thick white string. Create a string with a resist technique. Dennie loves to create bookmarks and tiles to present as personal gifts.

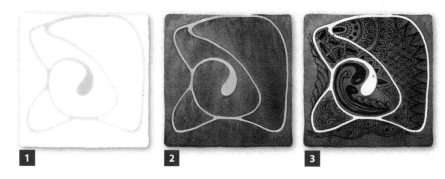

1. Drizzle rubber cement in a string line on a tile or cardstock. Note that when you hold the applicator up high, you get a thinner line. Let dry.
2. Spray the paper with a water mister. Spray colors of Dylusions watercolor inks in different corners. Let them mix. If needed, spritz more water and tilt the paper. Let dry.
3. Gently rub the surface to remove the rubber cement and reveal a white string. Draw tangles with a black MICRON 01 pen.

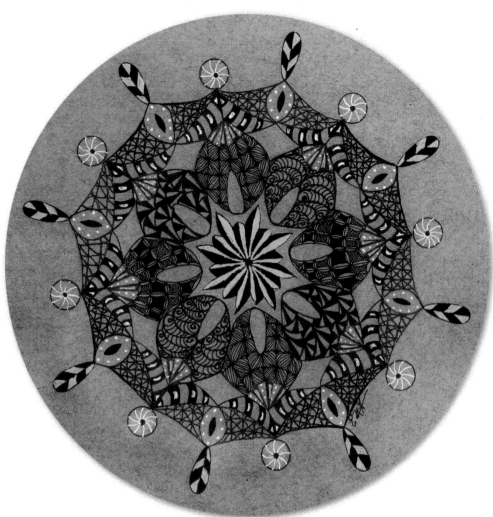

Zen Mandala

by Estelle M. Goodnight, CZT (Ohio)
EMGoodnight71@gmail.com

Estelle loves to draw tangles… and she especially loves mandala designs. She finds that Zentangle calms the mind. Drawing tangles helps reduce stress and improve focus. This relaxing process turns drawing simple patterns into artistic design.

Sand, turquoise, and earth colors give this piece a Southwest appeal reminiscent of a dream catcher. Draw tangles on an earth color piece of cardstock. Use color pens and markers to create drama and beauty.

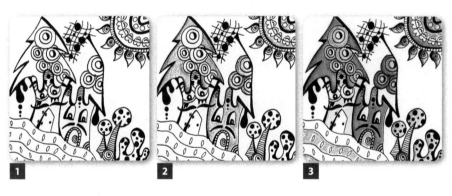

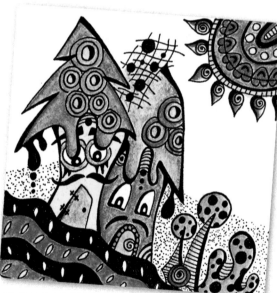

Tangled Houses

by Cindy Shepard, CZT (Texas)
cyndali.blogspot.com

Cindy's whimsical house designs embrace the unexpected with inspiring forms, creative shapes, and expressive compositions. She combines her tangled houses with trees, a landscape, and a colorful sun.

1. Draw a design with a black MICRON 01 pen.
2. Fill in selected areas with Inktense watercolor pencils or with colors of Gelly Roll pens.
3. Use a water brush (or a small brush and water) to blend the colors.

Tips for Inktense Watercolor Pencils
Use darker colors in areas for shading. To keep the colors from bleeding, wait until the first color is dry. Continue adding selected colors to the remainder of the design in the same manner.

Zentangle 9 Workbook

Welcome to the *Zentangle 9* workbook, where you will be able to put all the knowledge you've gained about adding color to Zentangle art with mixed media into practice. Start out by turning the page to master some of the tangles in this book with easy step-by-step practice spaces. Once you have them down, try shading some tangles with color using a variety of mediums from color pencils to watercolor paints. If you find tangling with color a little intimidating, use the resist strings with color already added—all you have to do is add the tangles. In no time at all, you'll see how easy it is to add color to your tangles.

You'll notice these pages have lots of space on them, and it's all for you! Just because a page might direct you to try a certain exercise doesn't mean you have to. Use any blank space to draw tangles, experiment with color, or create Zentangle art—whatever you want! This is your place to play, experiment, and create.

Don't be intimidated. Just like there are no mistakes in Zentangle, you can't do anything wrong in this workbook. These pages are yours to do with as you please. If a color choice or tangle does not turn out quite the way you intended, find a new blank space and try again. Take what you learned from your first try and apply it to your second. Keep drawing, and you'll be amazed at the results.

Happy tangling!

by Marizaan van Beek, CZT (South Africa)
marizaanvb@gmail.com

Draw-it-Yourself Tangles

Want to practice the steps of a tangle? Here's your place to experiment. Try recreating the tangles here, step by step, and use the extra boxes and space to create your own variations and adaptations.

Victory

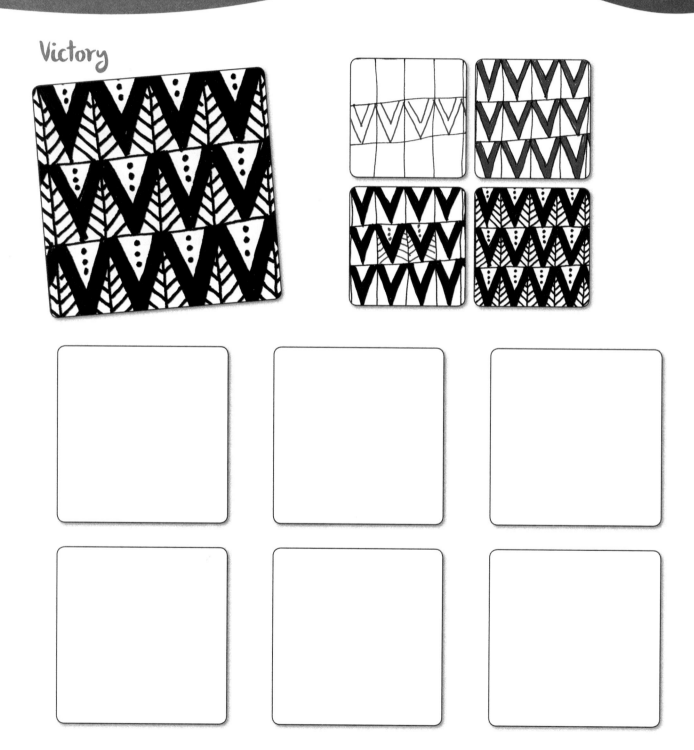

Roller

Variation Variation

Poin

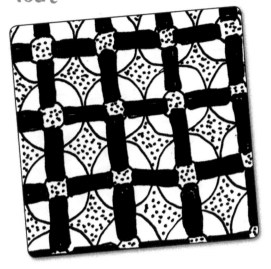

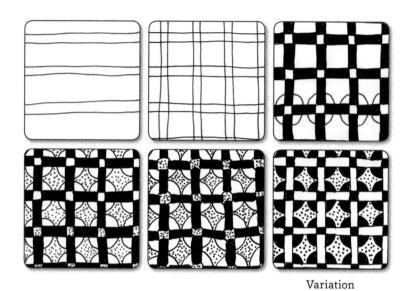

Variation

Stoppers

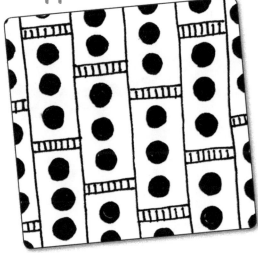

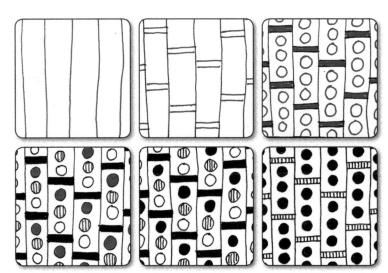

Variation

Shading with Color

Page 3 offers up some wonderful ideas for adding color shading to your Zentangle pieces, and here is your space to practice. Try adding color shading to the designs here. You can use anything from colored pencils and crayons to markers and watercolors. Try adding shading to only the outer edges of a tangle. Then, try adding shading only to the center point working outward. How do they look different? Which one do you like better?

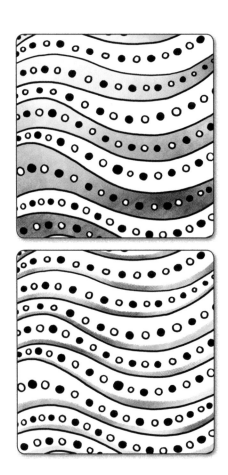

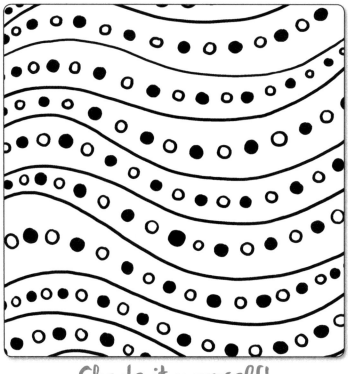

Shade it yourself!

Shade it yourself!

Shade it yourself!

Shade it yourself!

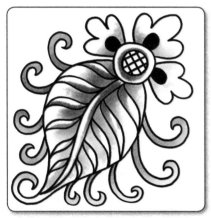

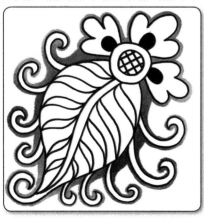

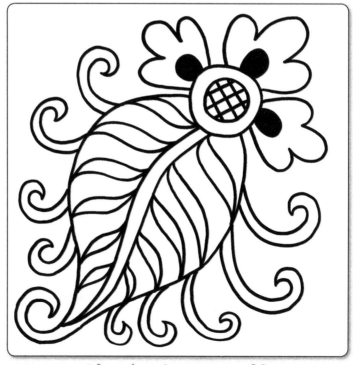

Shade it yourself!

Shade it yourself!

Shade it yourself!

Experiment with Resist Strings

As the technique on page 15 shows, an easy way to add color to your art is by creating a reversed string in white against a color background. Try adding tangles to these color-vvfilled spaces to see how a little color can make your Zentangle art come to life. If you want to try creating your own resist string, it is recommended that you do it on a tile or cardstock. Play with mixing colors to create fun backgrounds for your tangles.

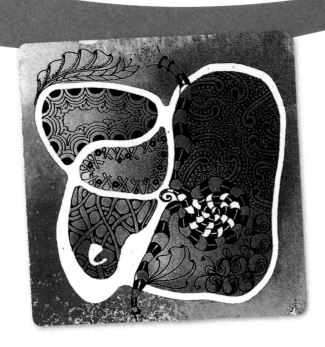

Add your own tangles!

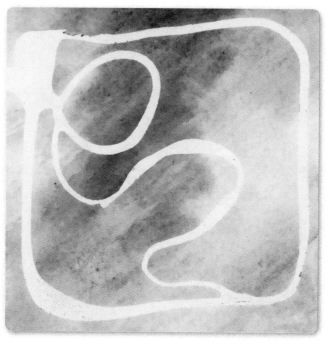

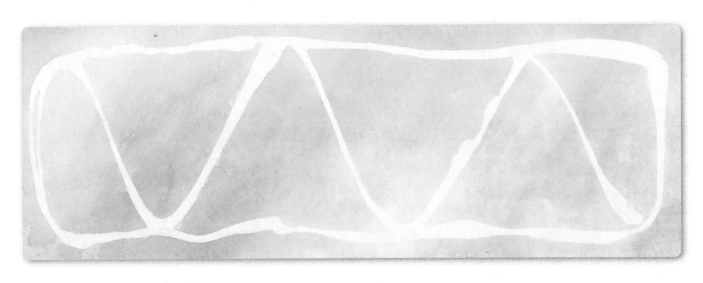

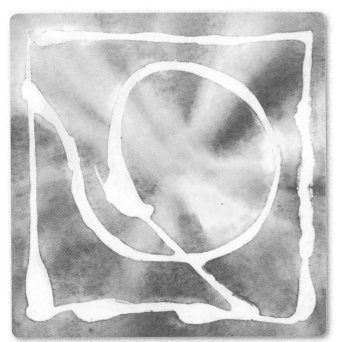

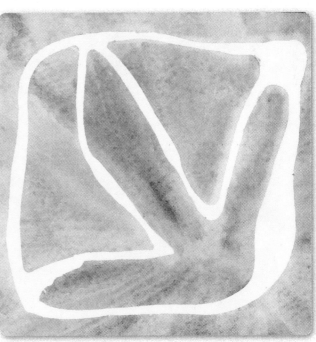

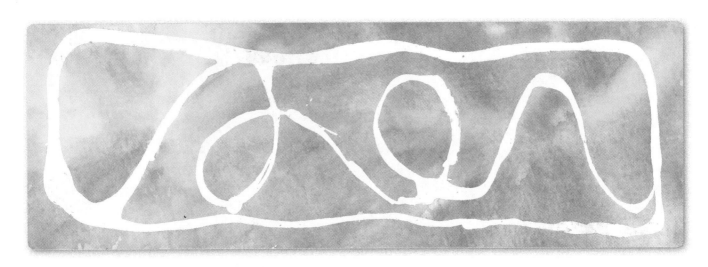

Tiny Tangles Patchwork

Using the Tiny Tangles technique on page 5, create a colorful patchwork of shapes using the template as a guide. Add tangles to your colored shapes. To take your artwork even further, add tangles to the background to tie the colored squares together.

Add your own tangles!

Adding Embellishment

Practice using Zentangle patterns to add embellishment to a piece of art. If you want to add even more texture, use various coloring techniques with your tangles to really make a piece pop!

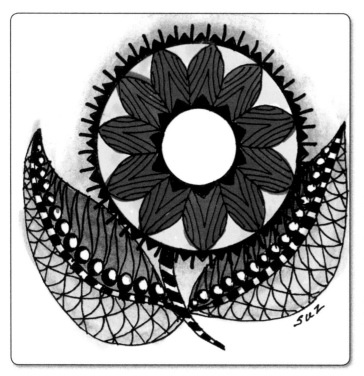

Embellish it yourself!

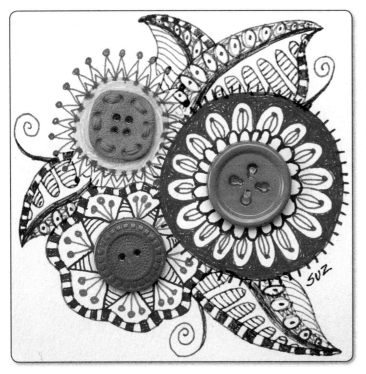

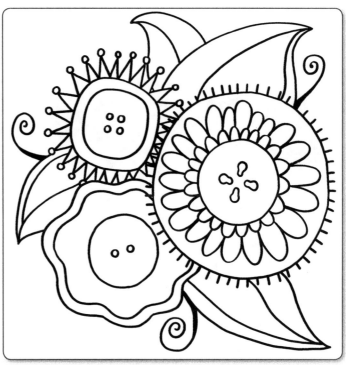

Embellish it yourself!

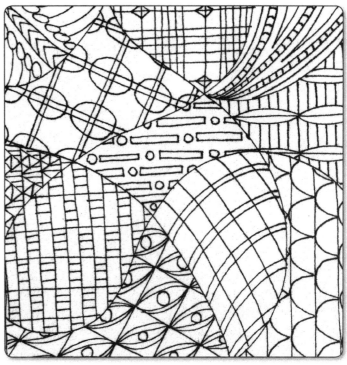

Embellish it yourself!

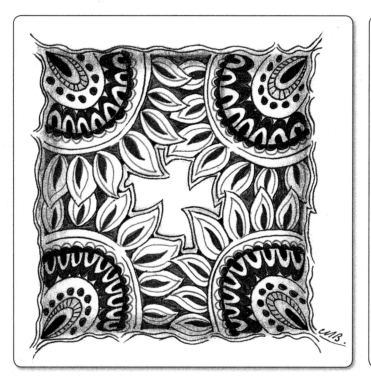

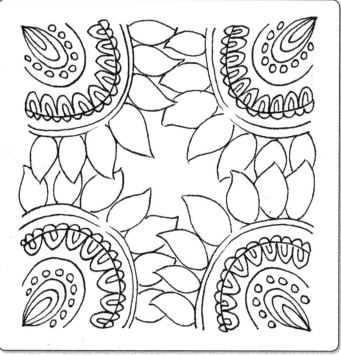

Embellish it yourself!

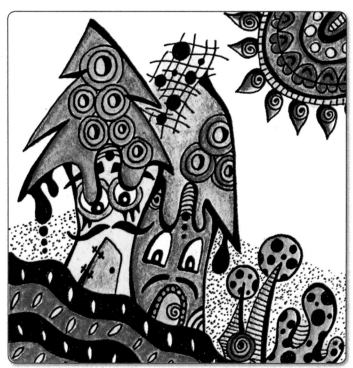

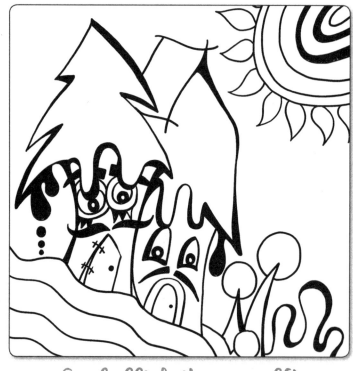

Embellish it yourself!